# Fun with the Sun

## Coloring Book

JOSEPH G. CAMERON

Copyright © 2019 Joseph G. Cameron.

All rights reserved. No part of this book may be reproduced, stored, or transmitted by any means—whether auditory, graphic, mechanical, or electronic—without written permission of the author, except in the case of brief excerpts used in critical articles and reviews. Unauthorized reproduction of any part of this work is illegal and is punishable by law.

ISBN: 978-1-6847-0238-1 (sc)
ISBN: 978-1-6847-0486-6 (e)

Because of the dynamic nature of the Internet, any web addresses or links contained in this book may have changed since publication and may no longer be valid. The views expressed in this work are solely those of the author and do not necessarily reflect the views of the publisher, and the publisher hereby disclaims any responsibility for them.

Any people depicted in stock imagery provided by Getty Images are models,
and such images are being used for illustrative purposes only.
Certain stock imagery © Getty Images.

Lulu Publishing Services rev. date: 09/10/2019

*In loving Memory*

# Theresia Cameron (Mama)

*She brought beauty and light to this world.*

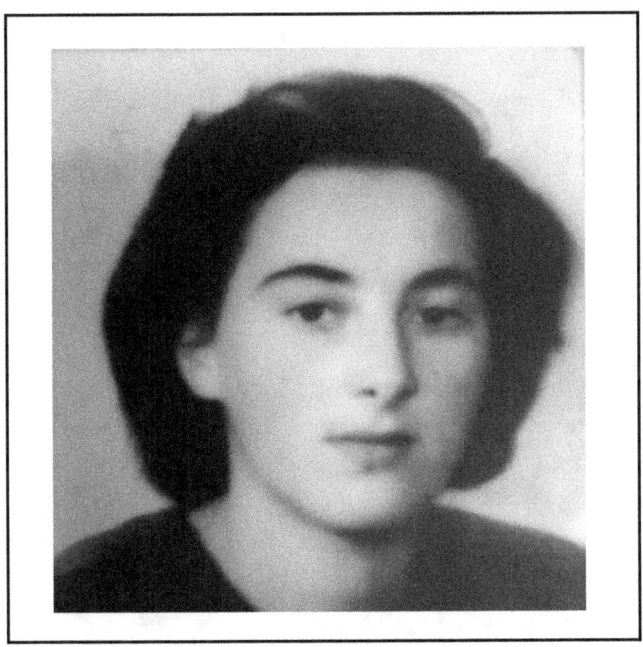

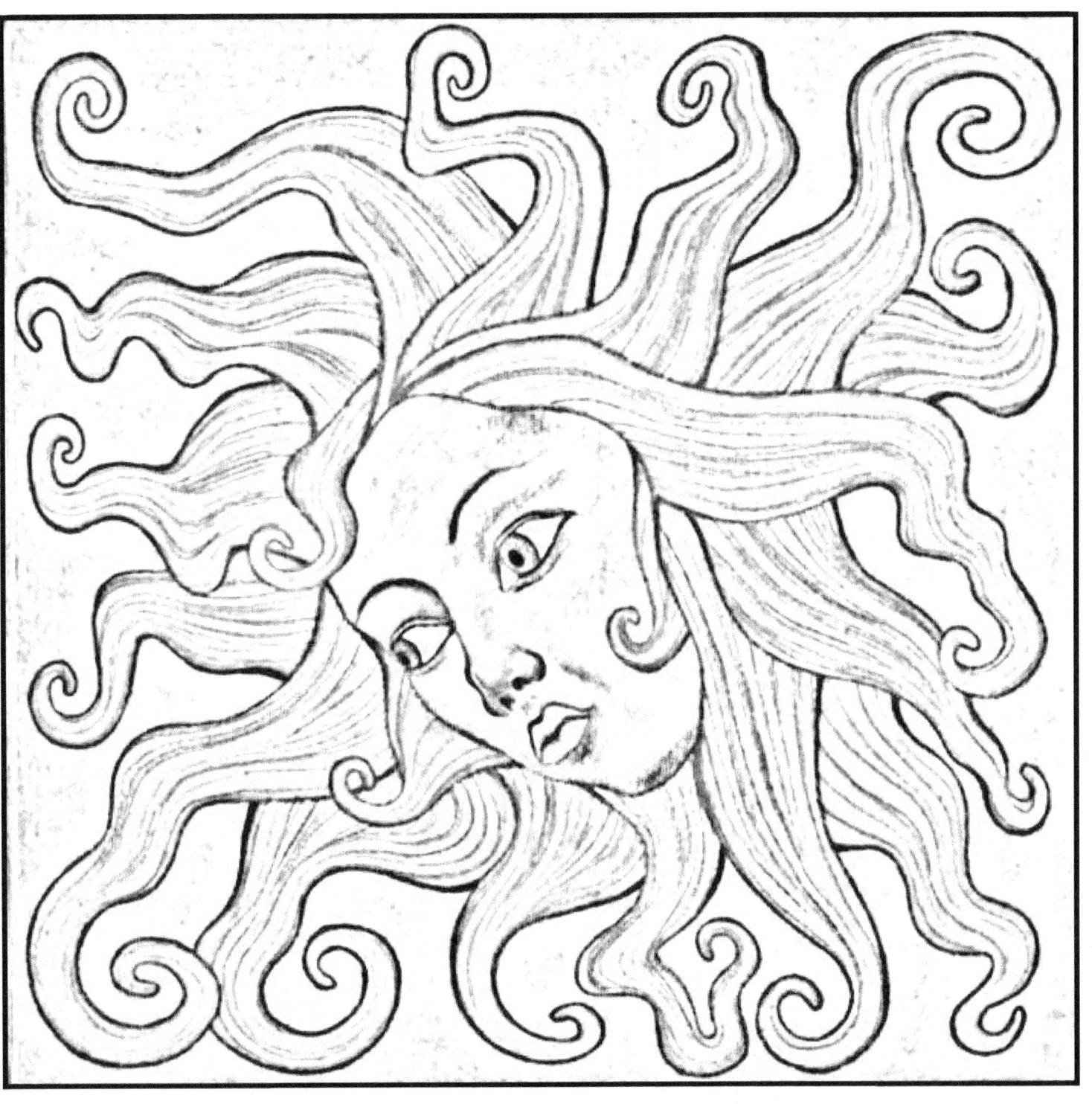

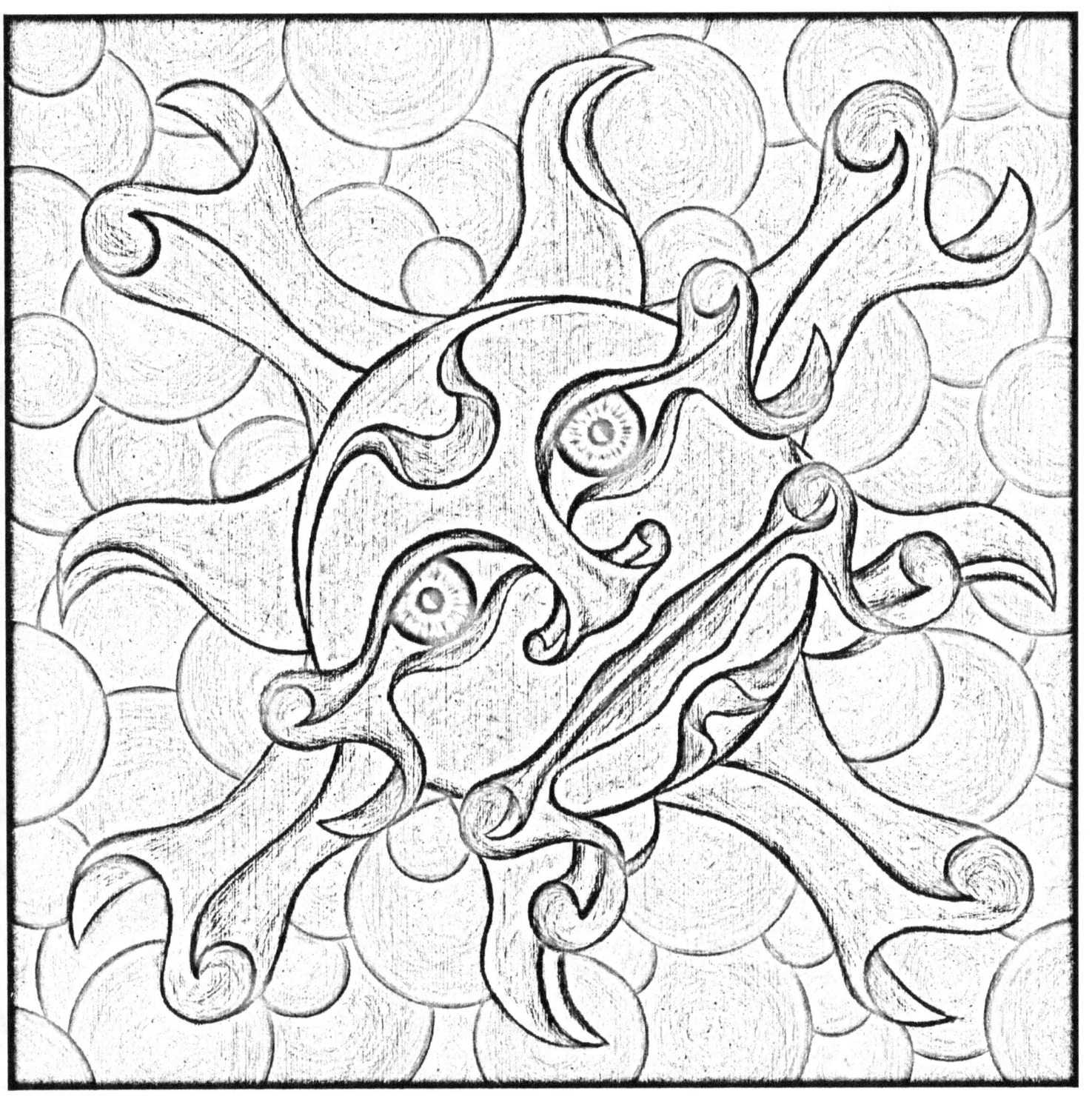

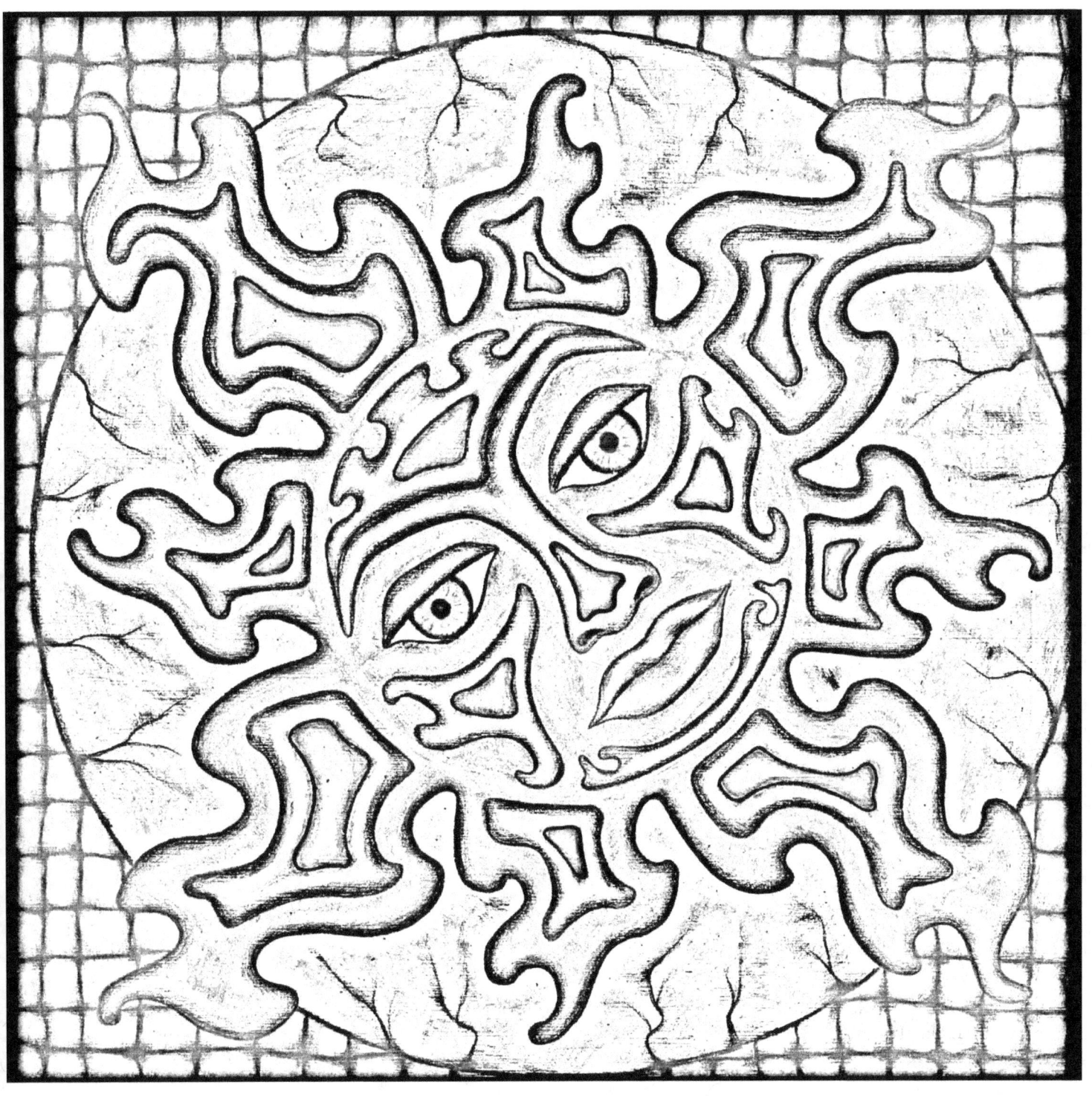

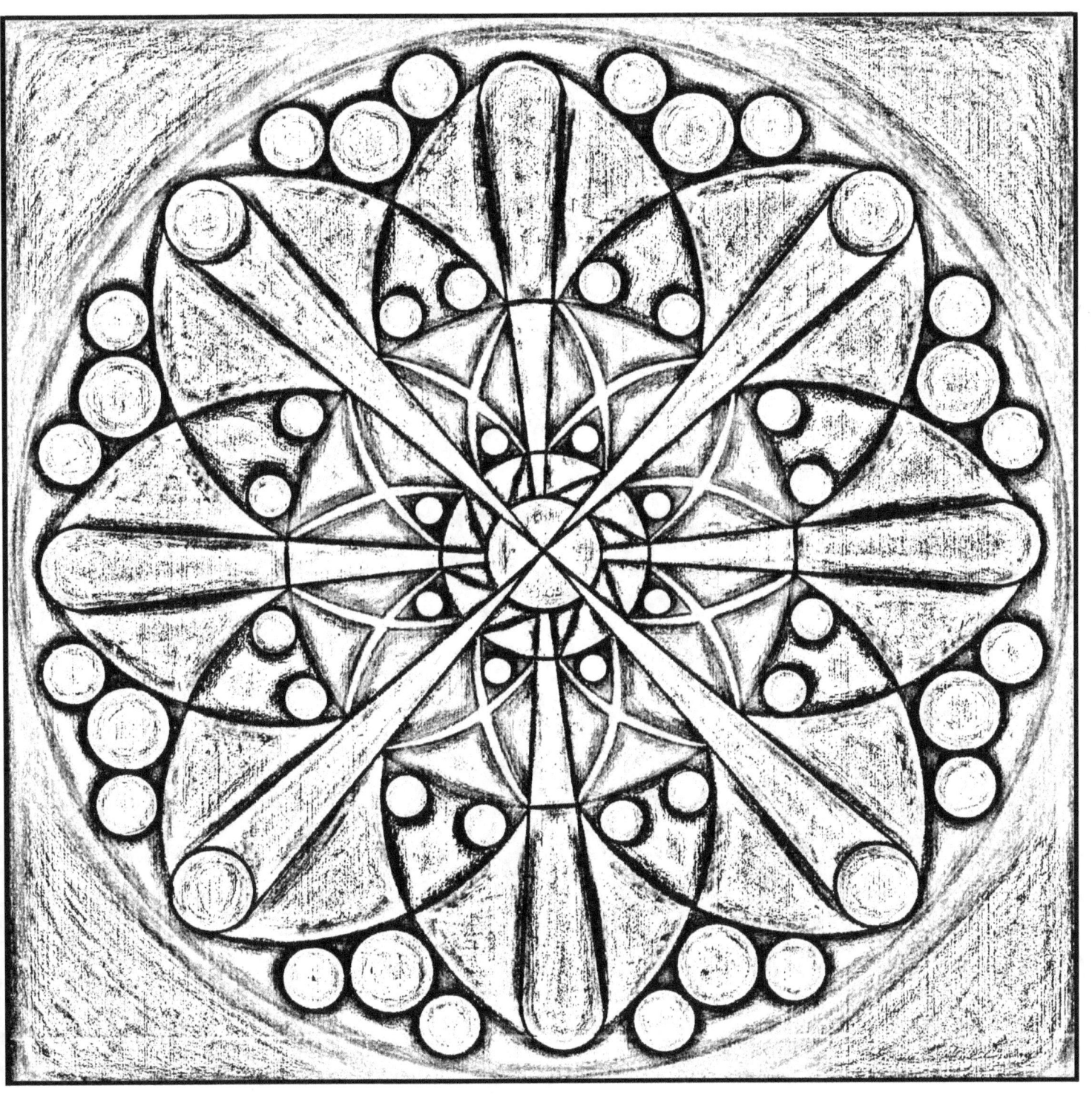

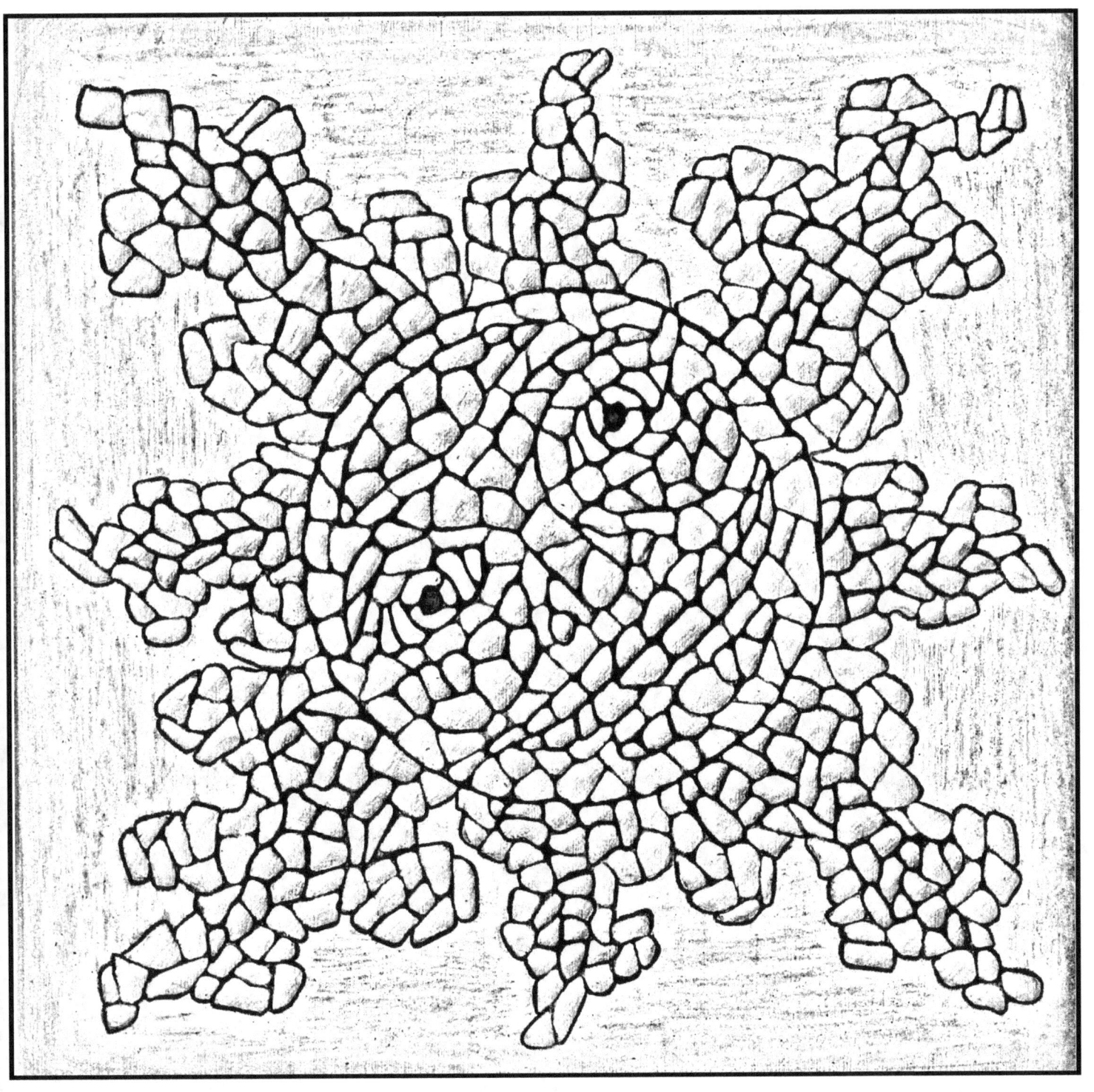

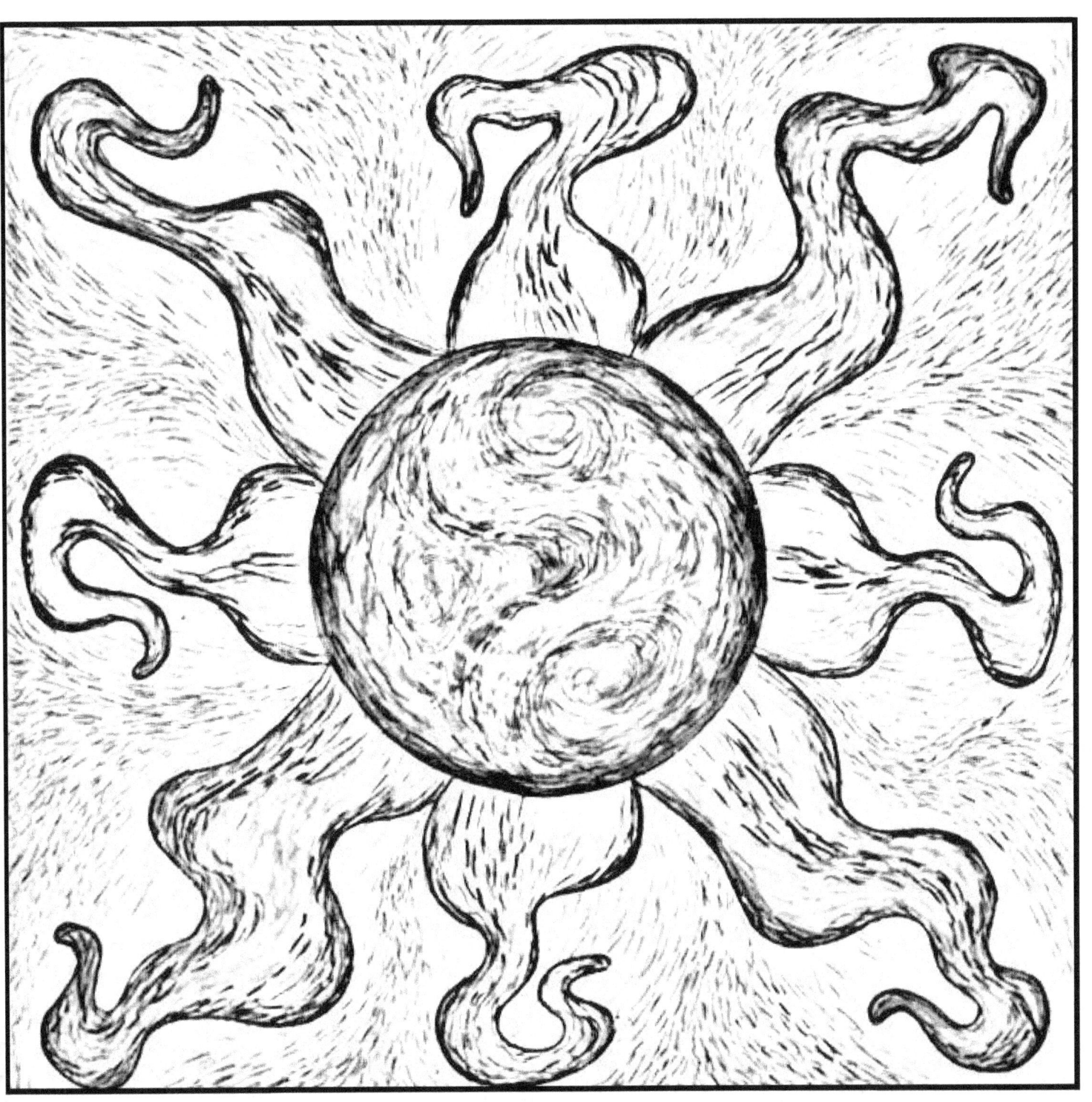

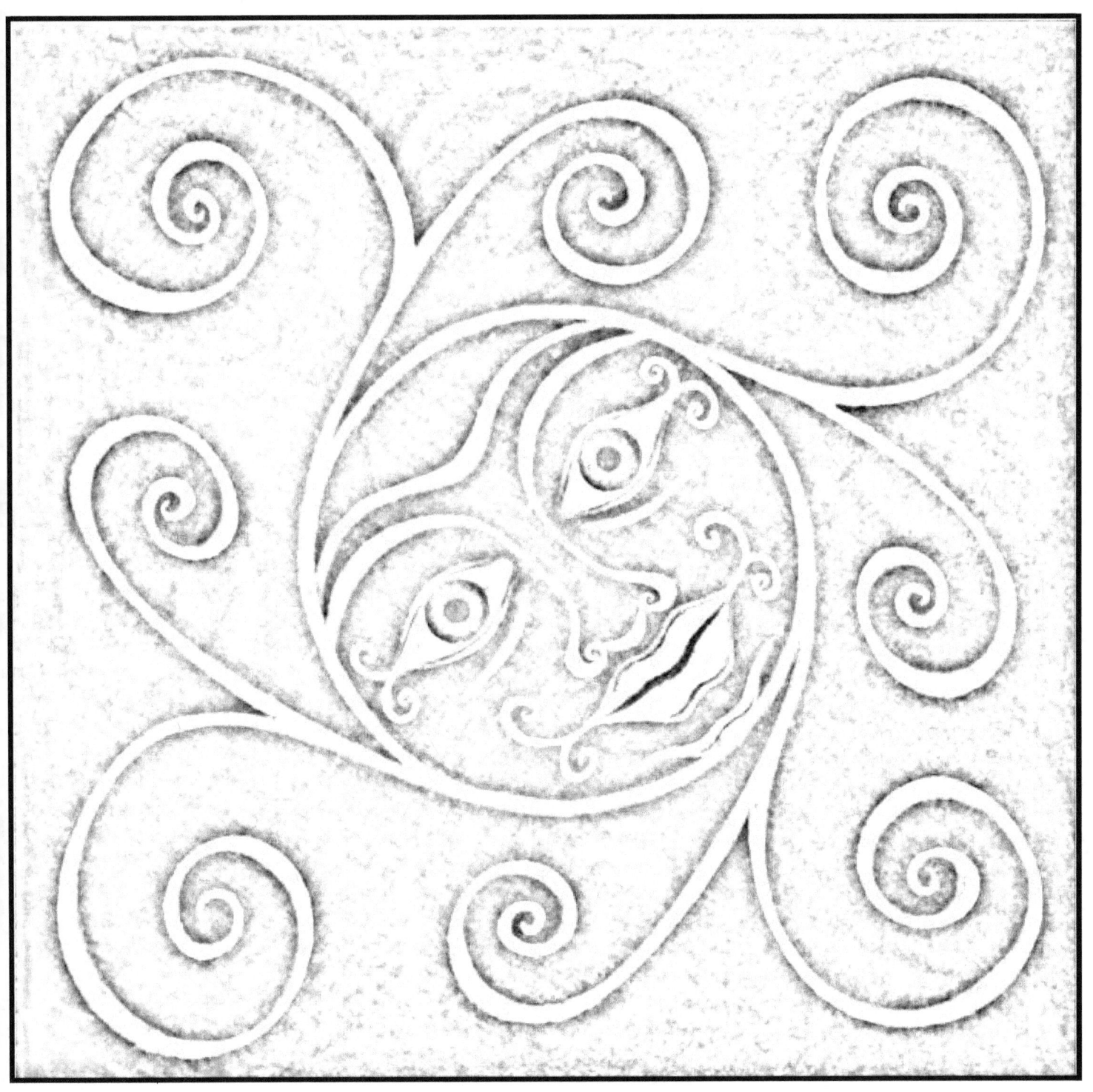

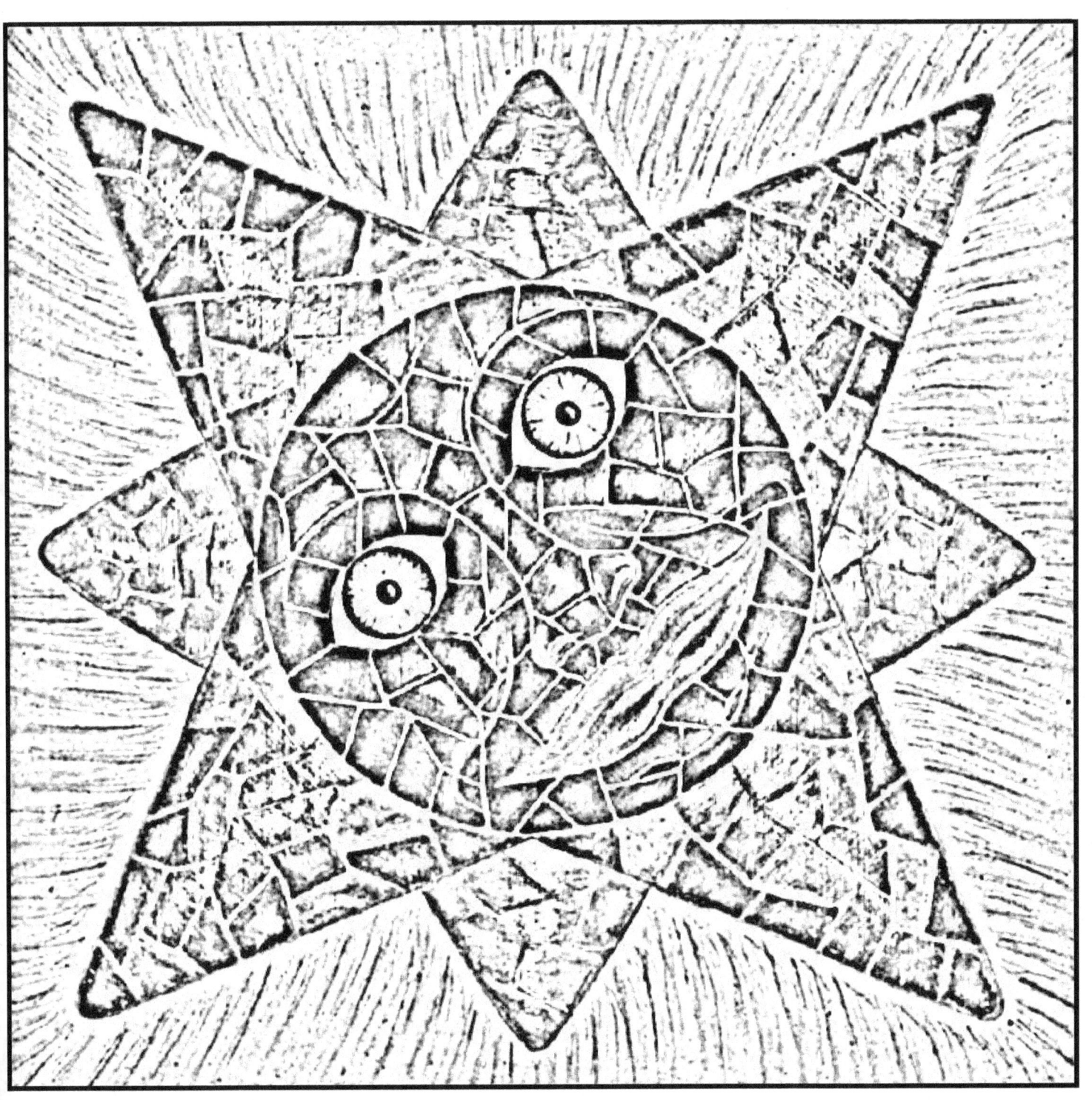

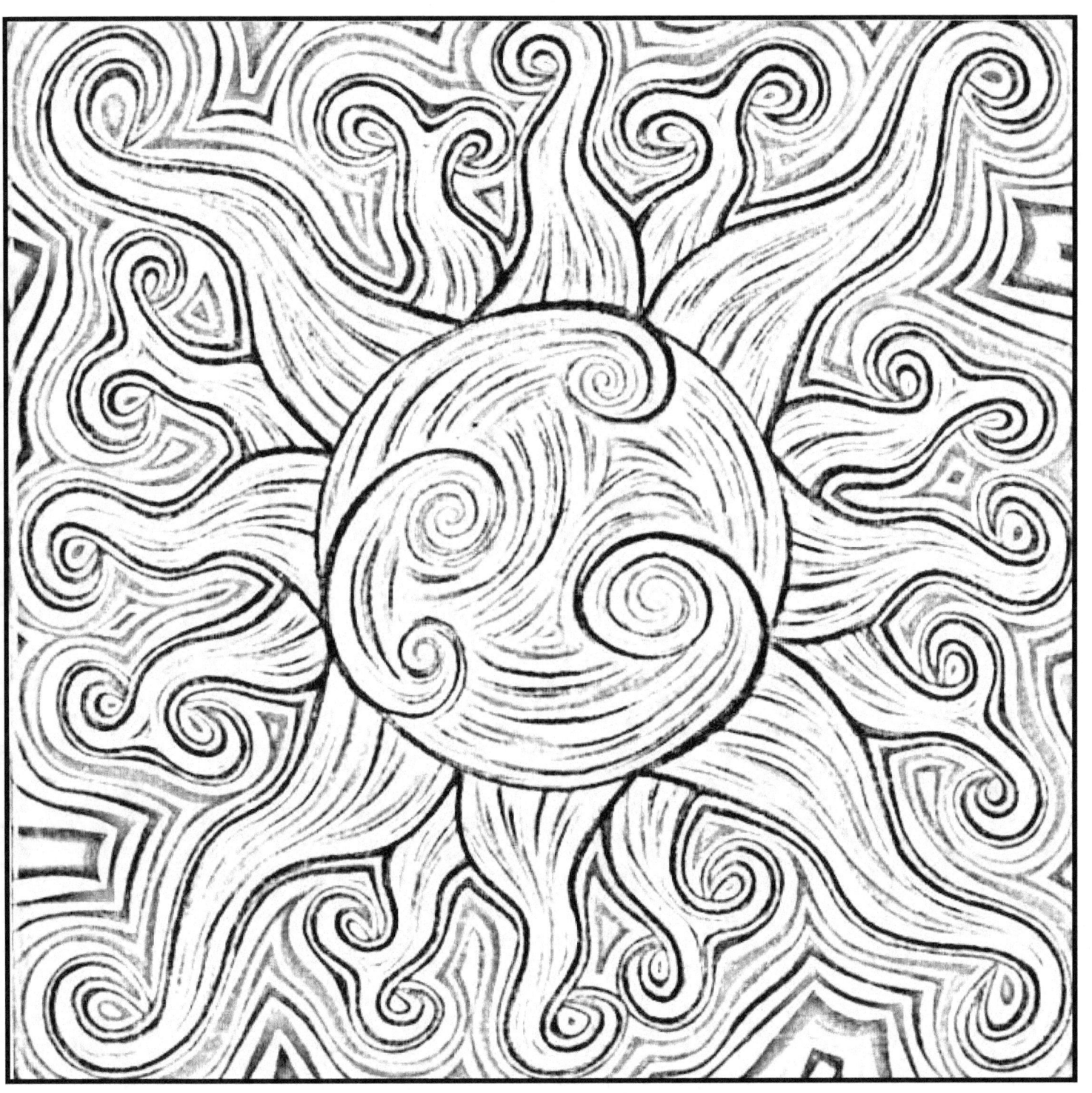

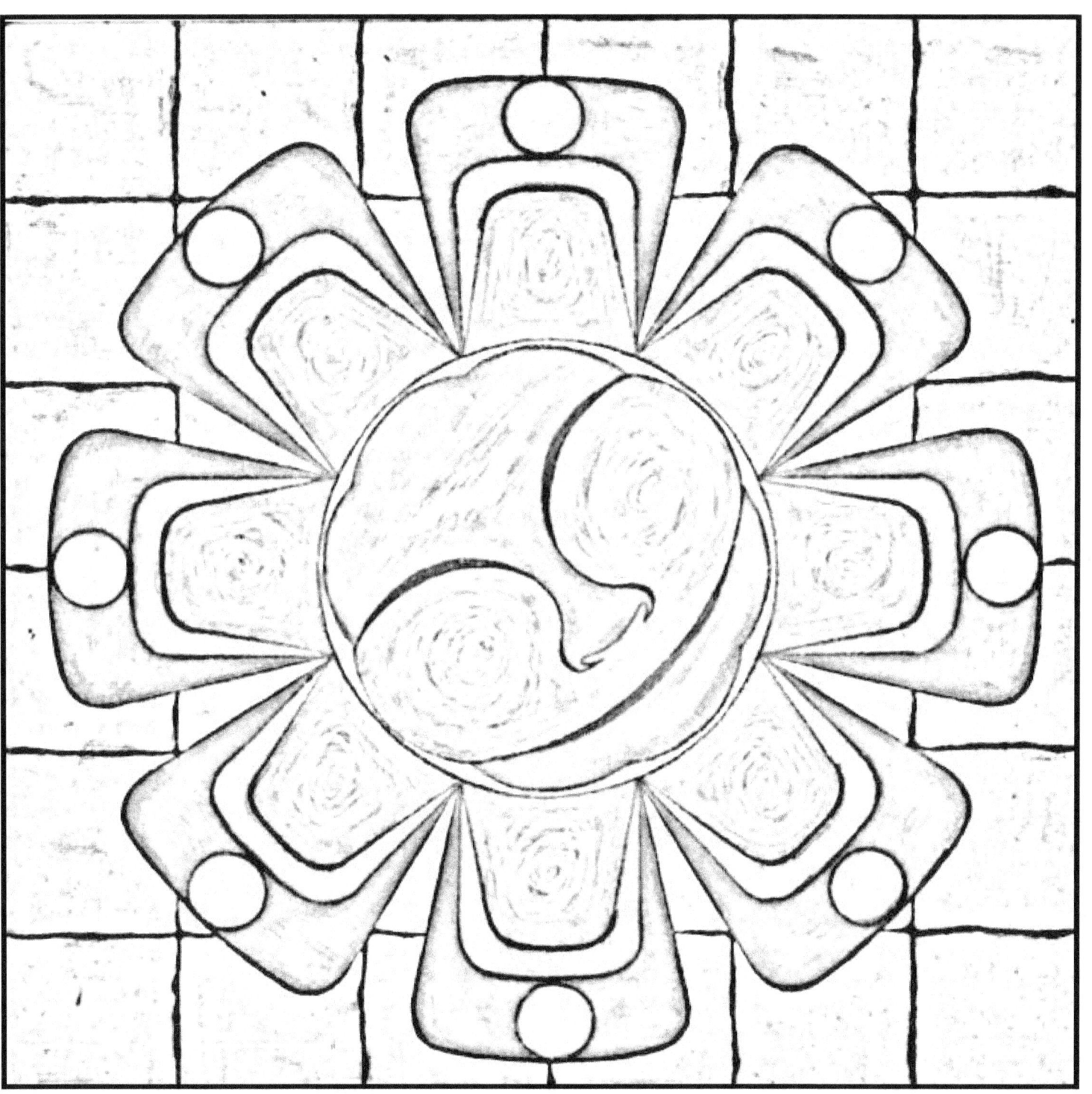

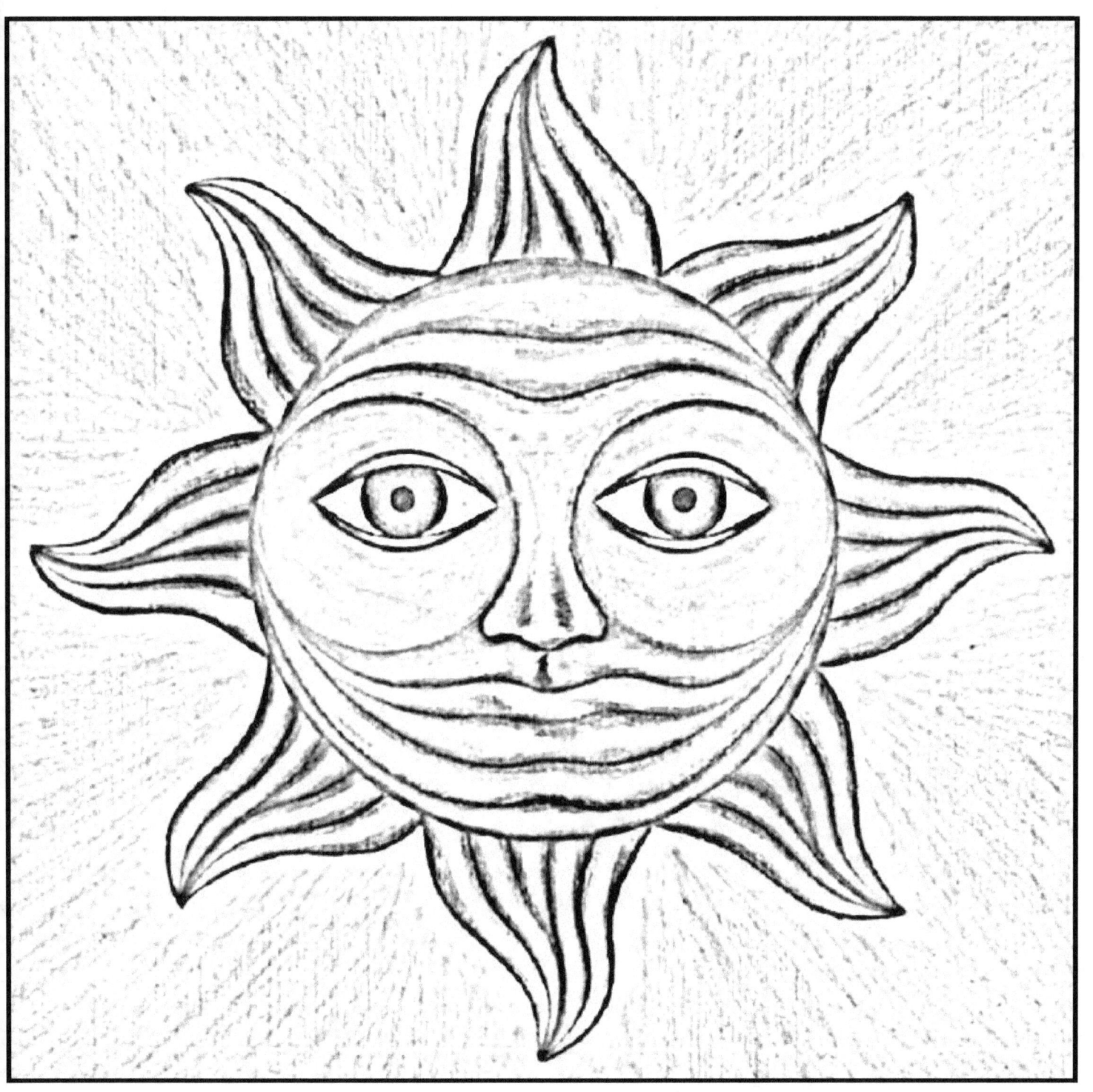

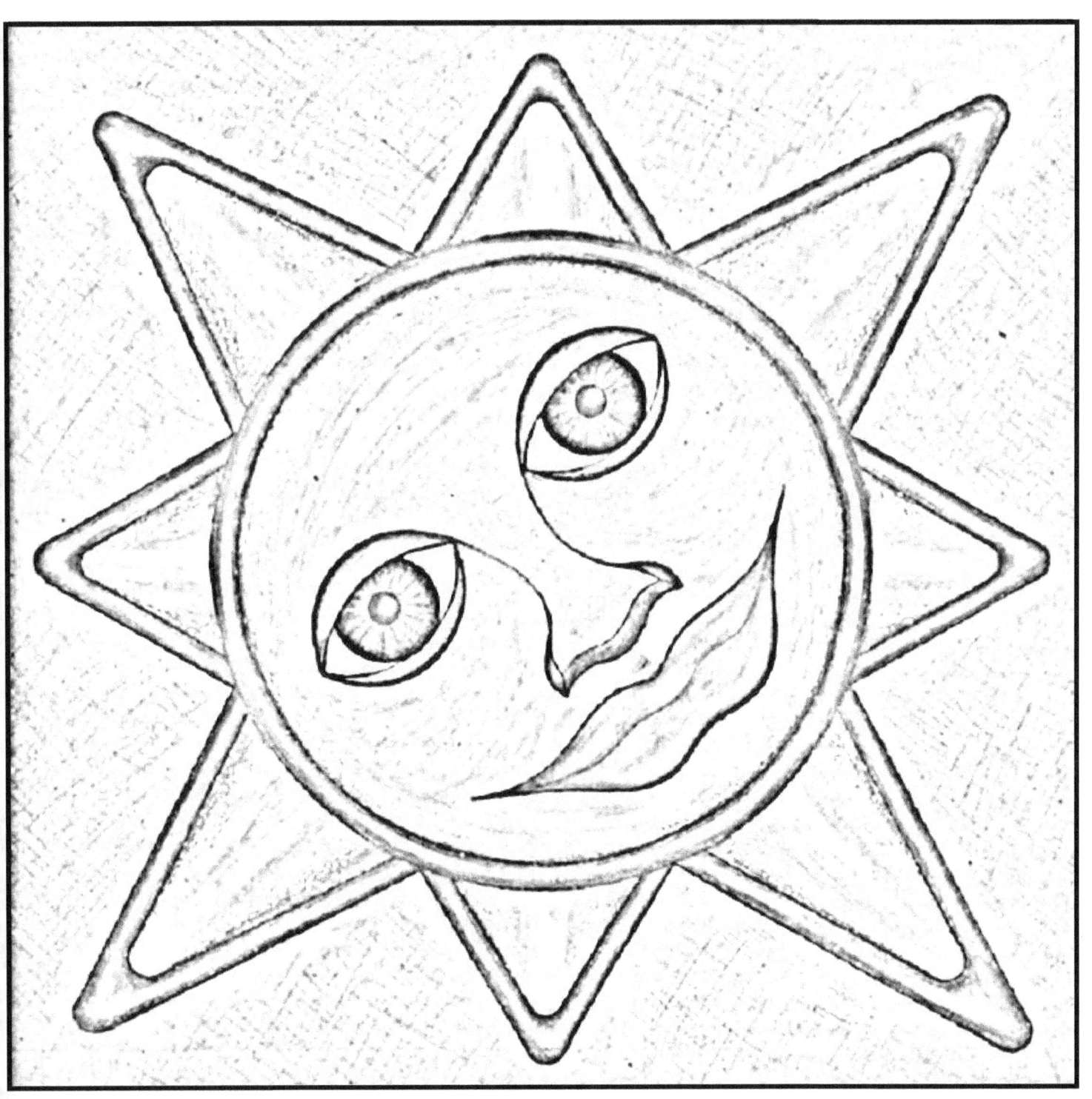

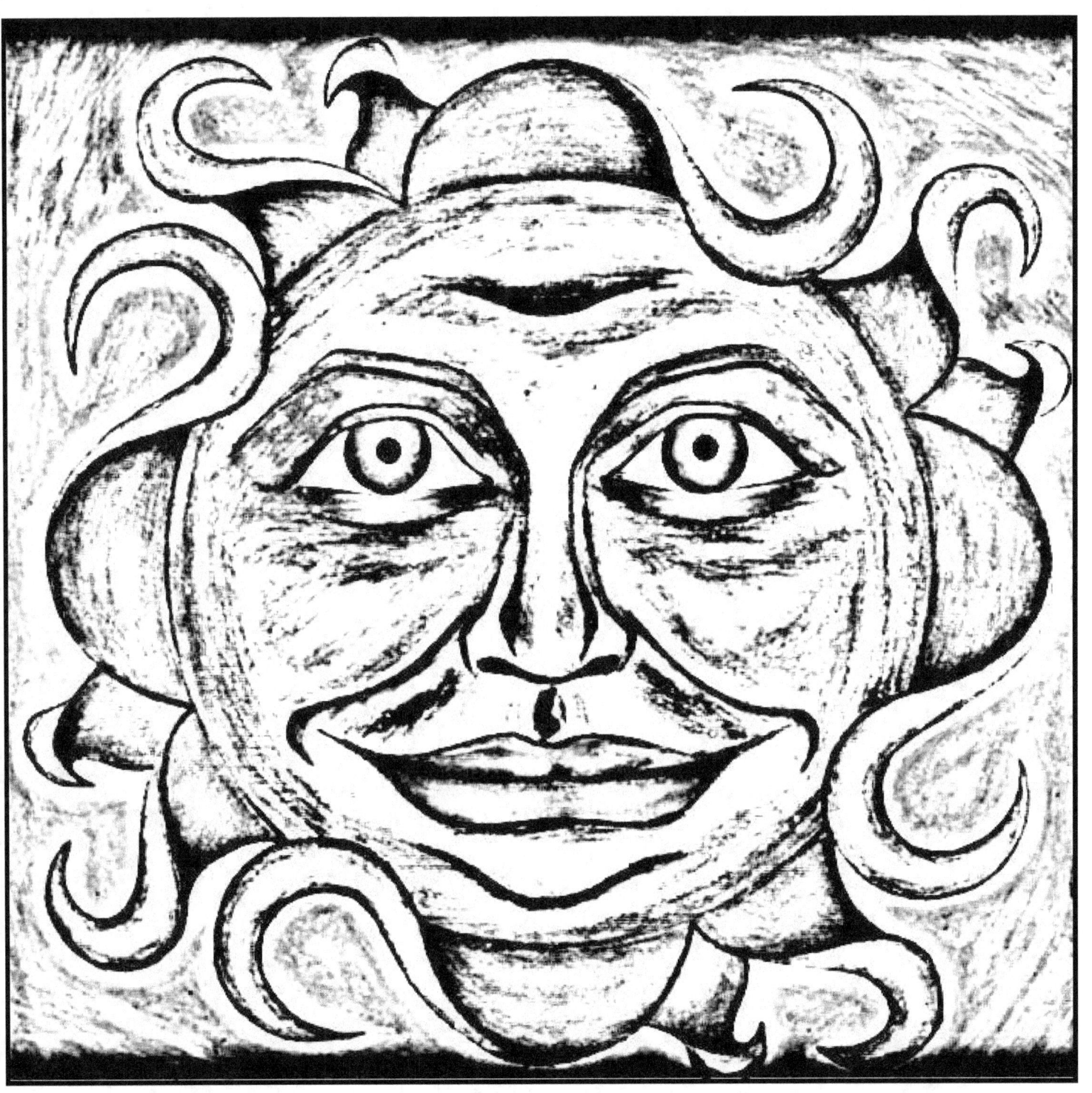

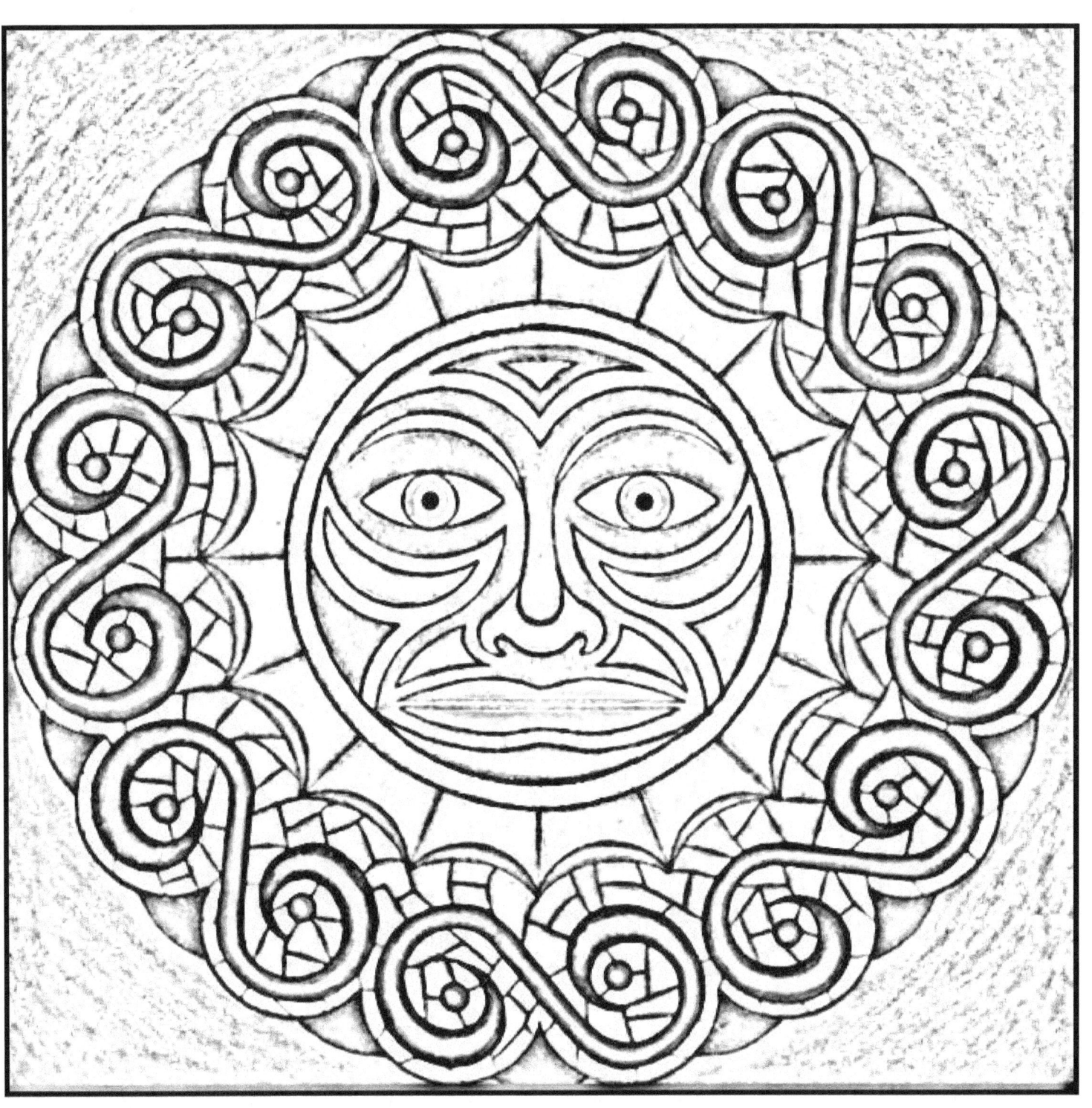

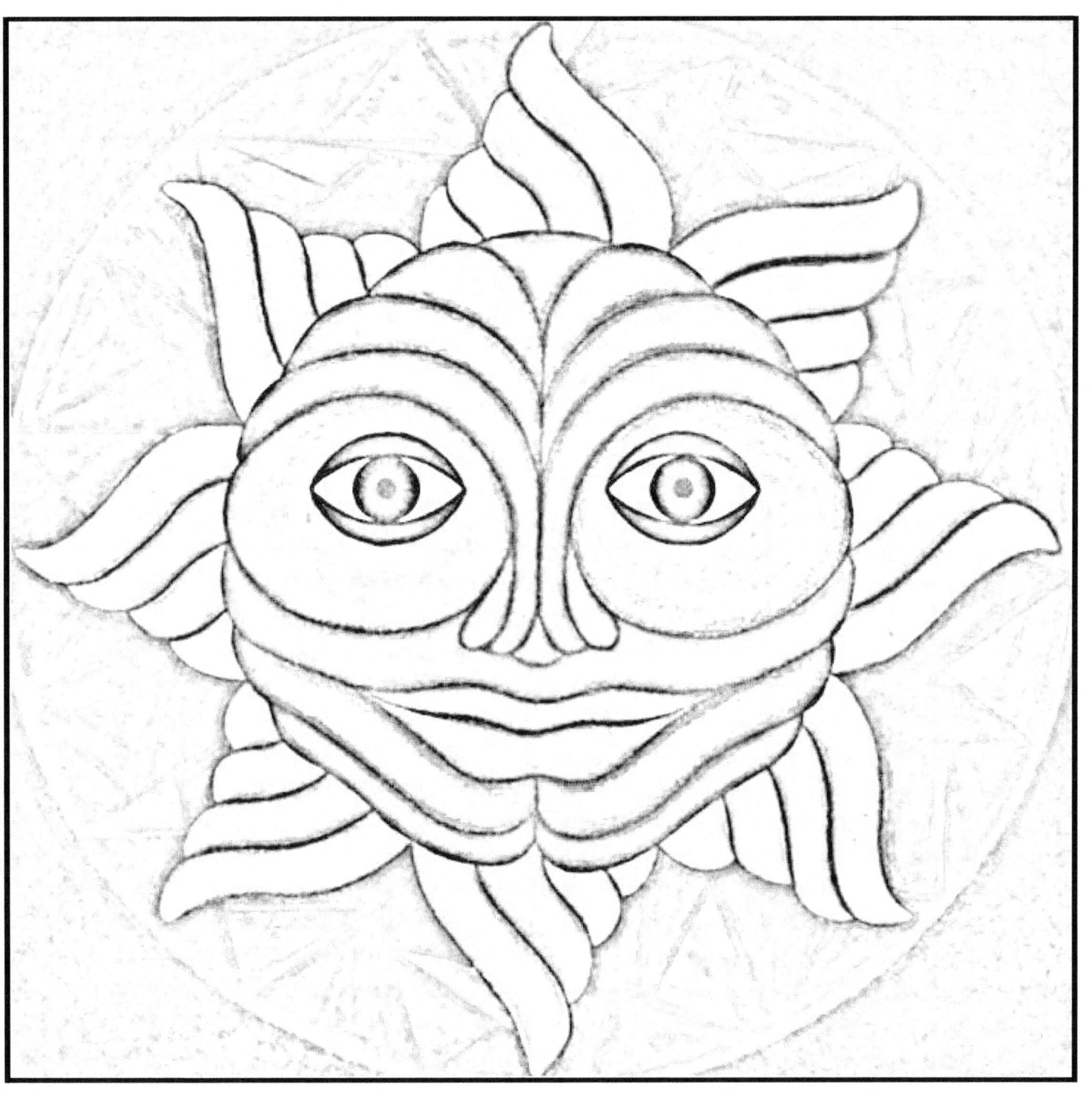

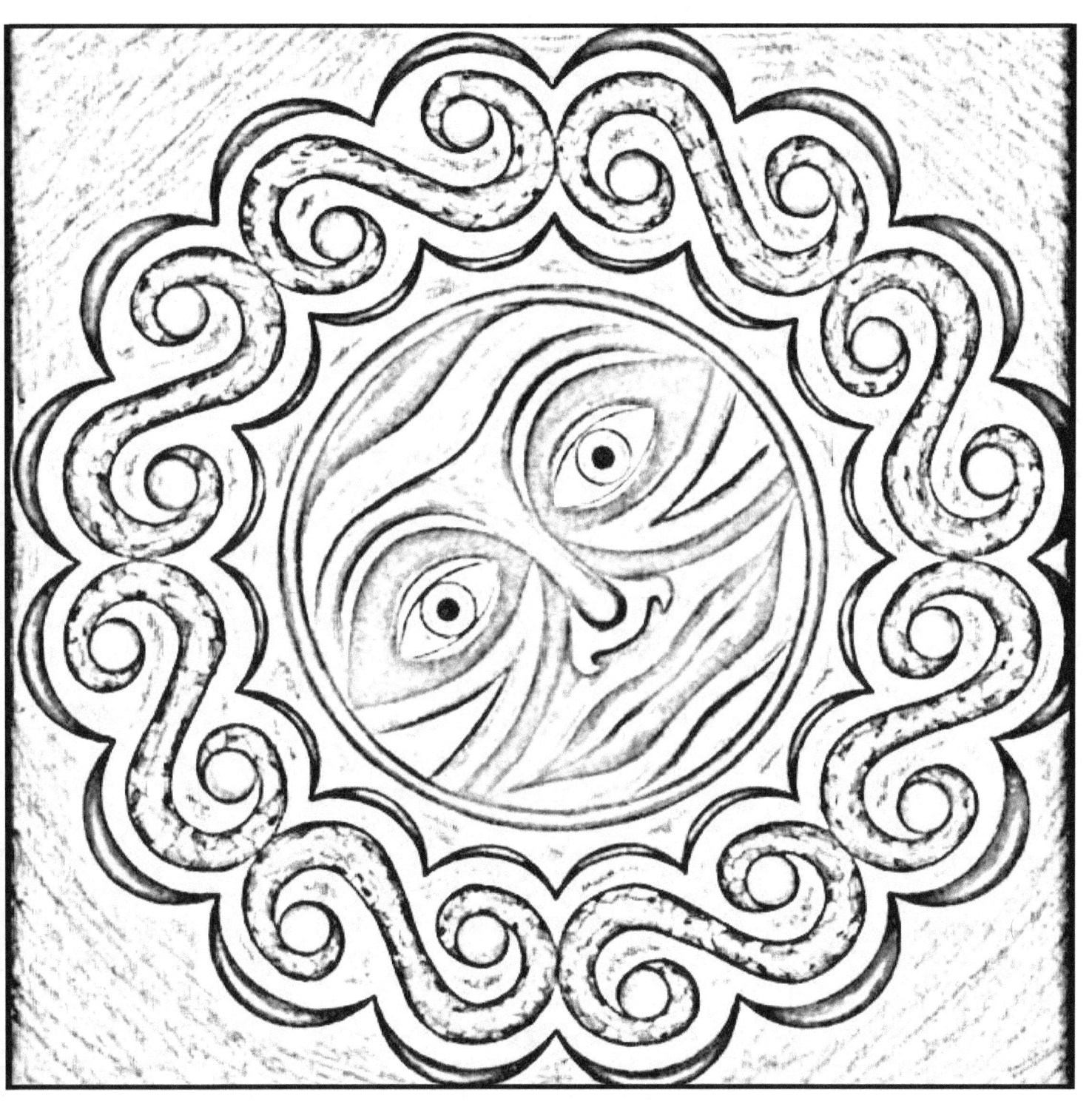

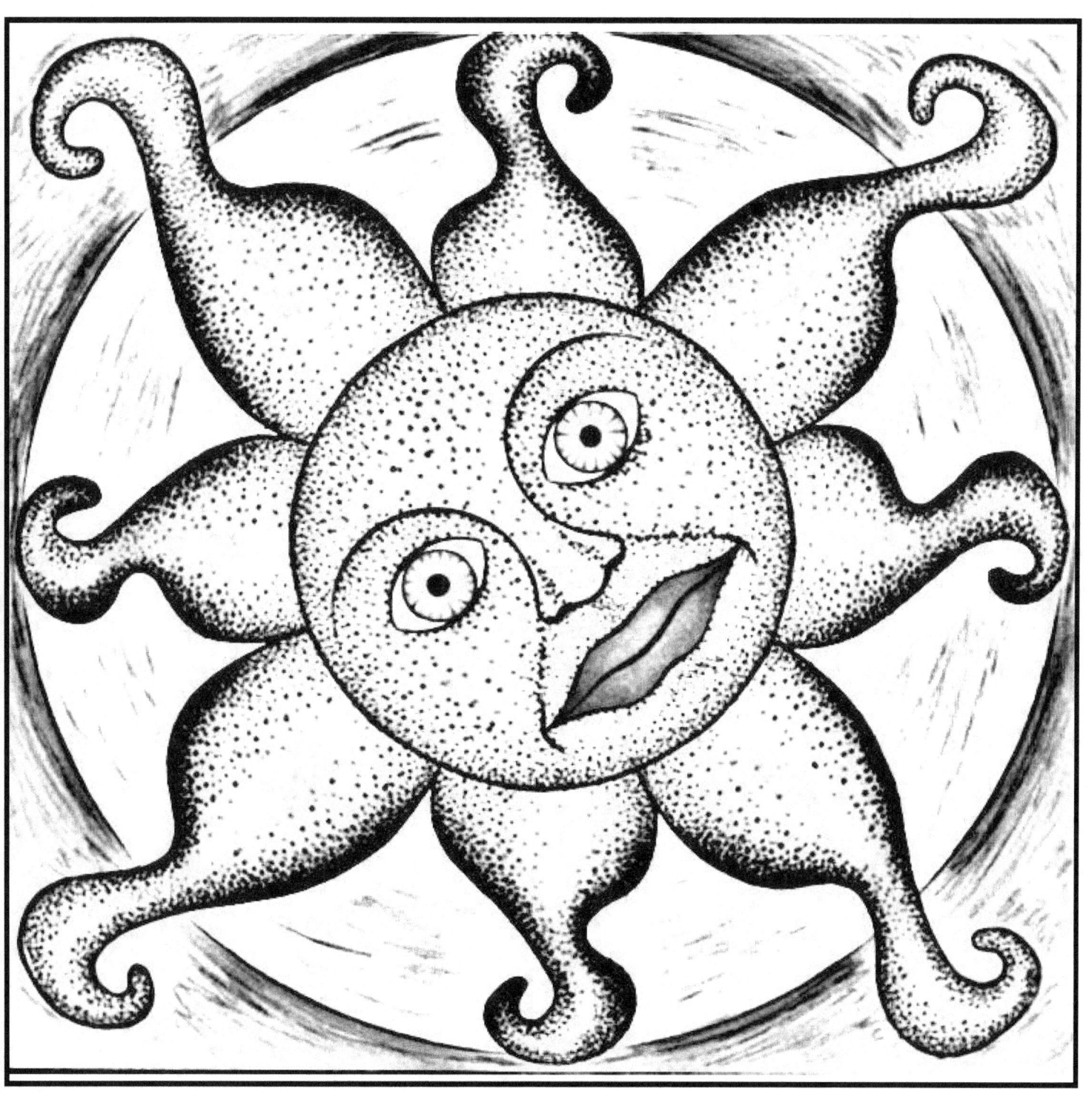

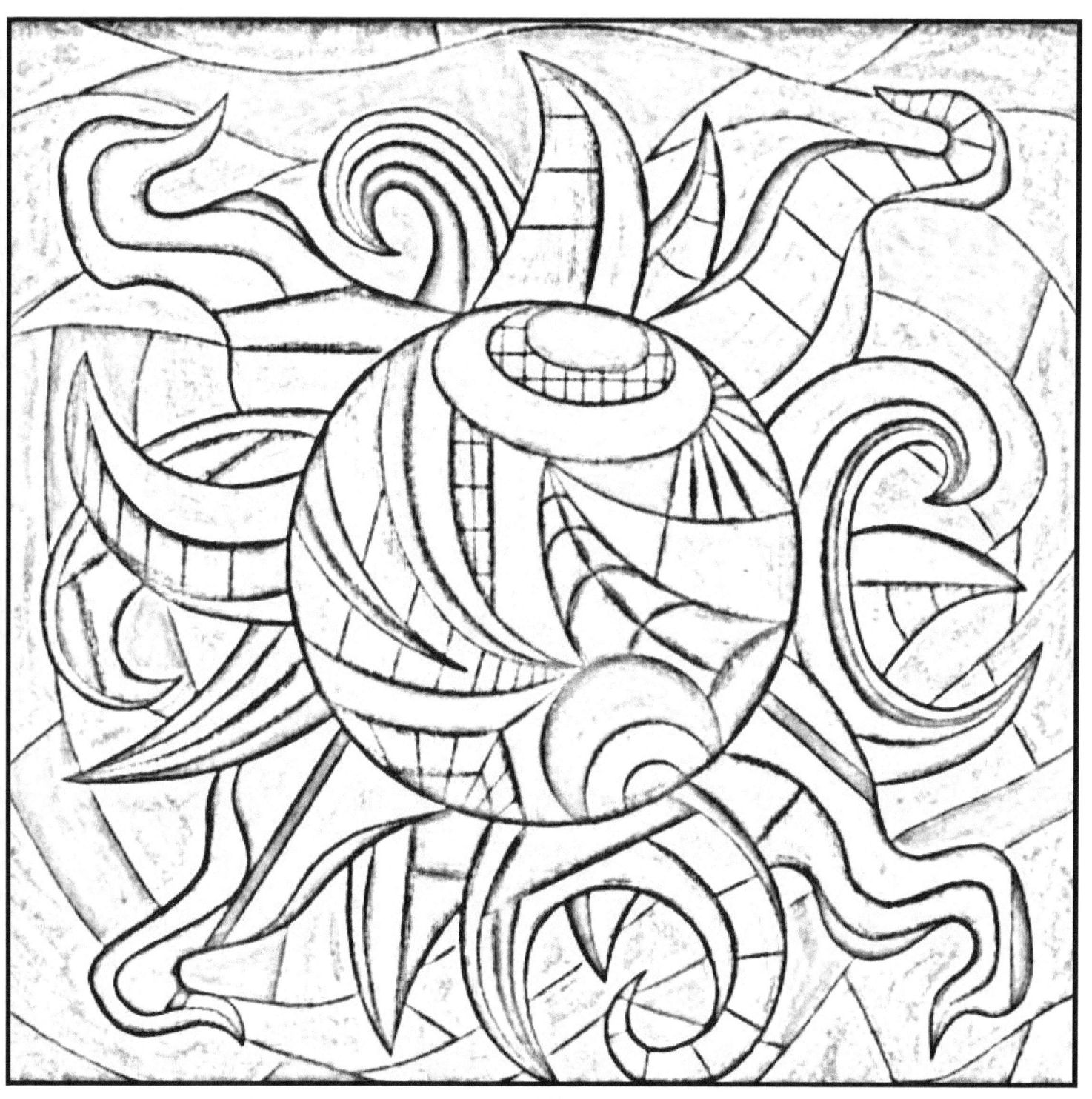

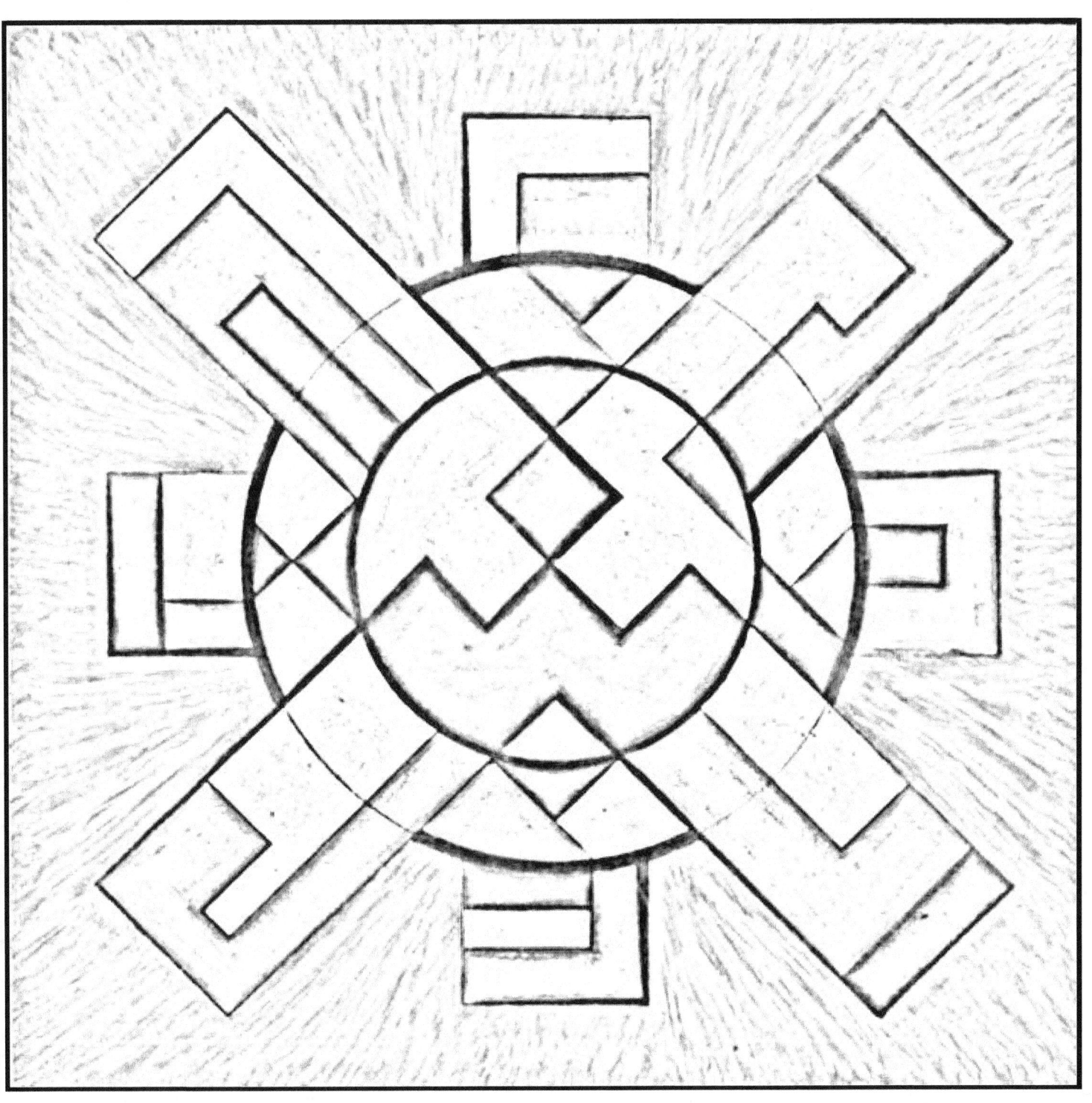

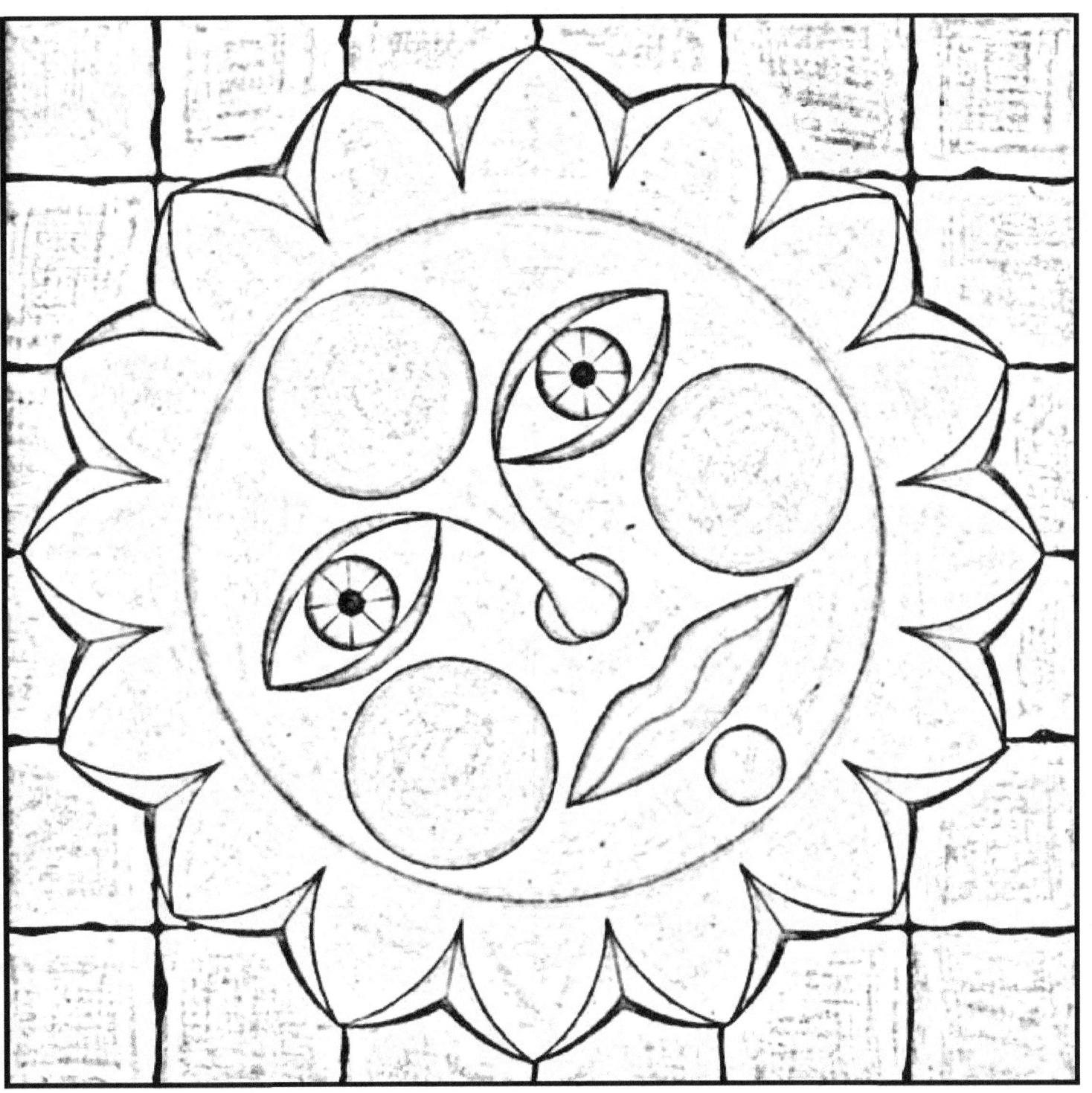

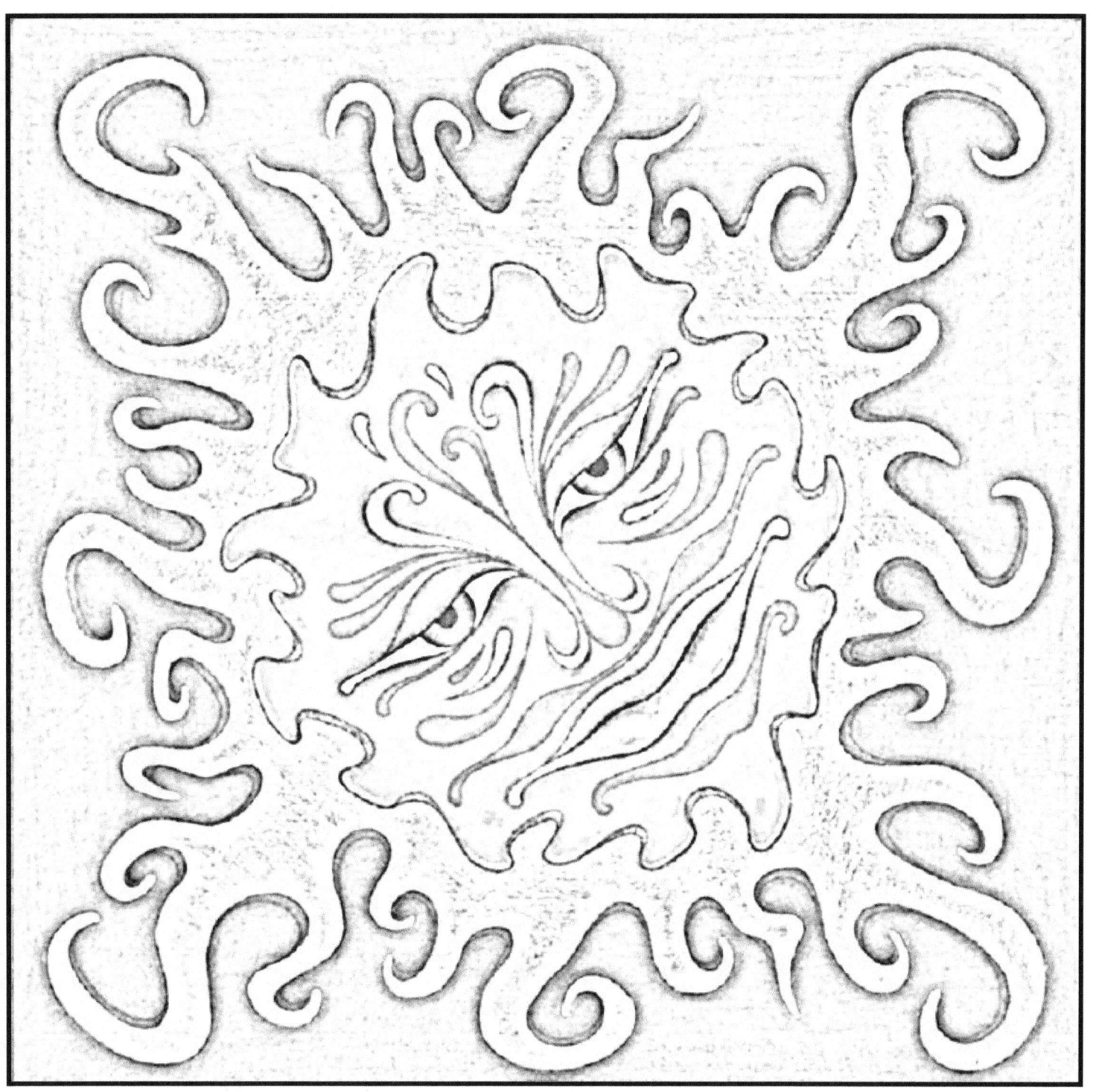

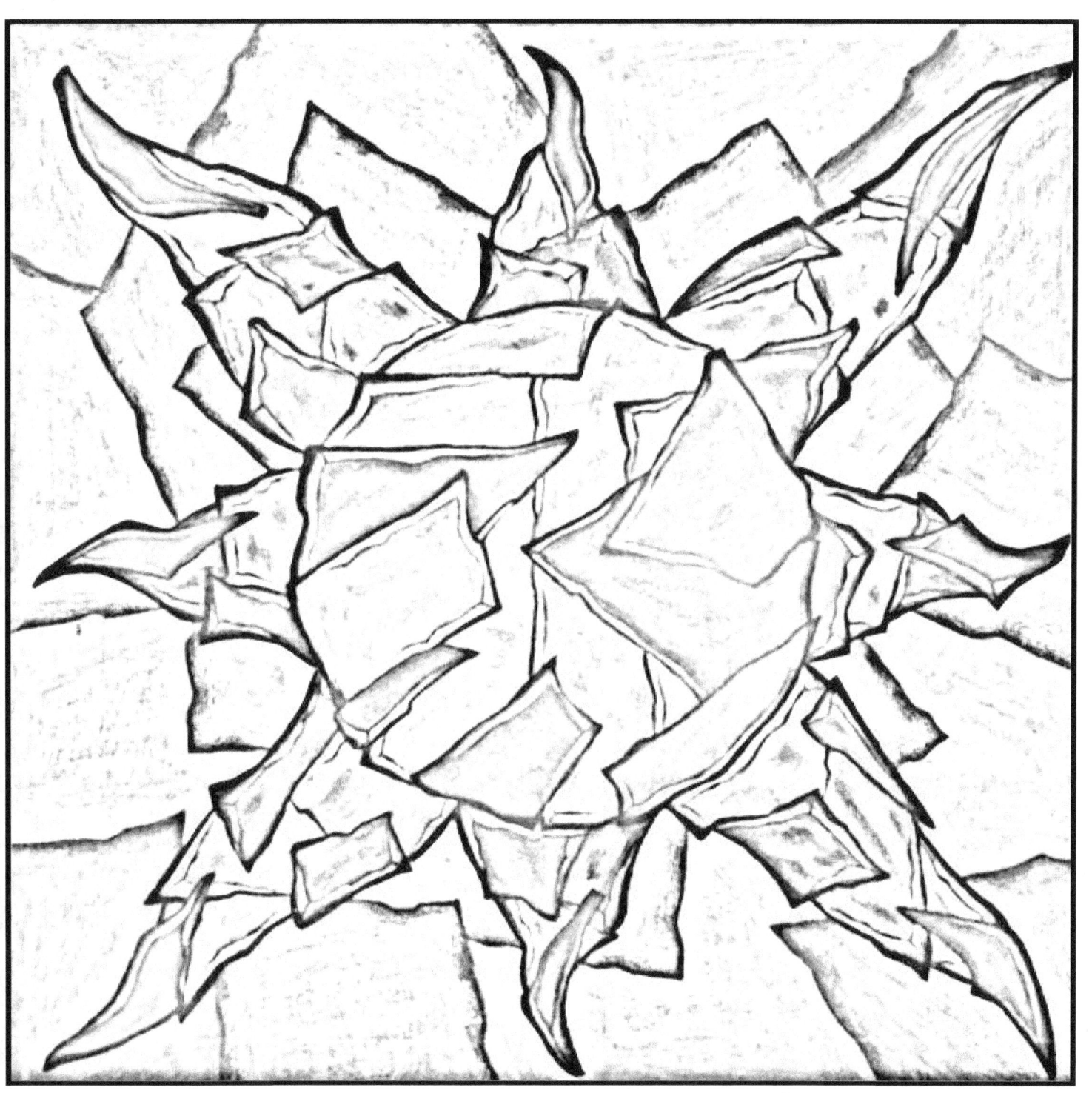

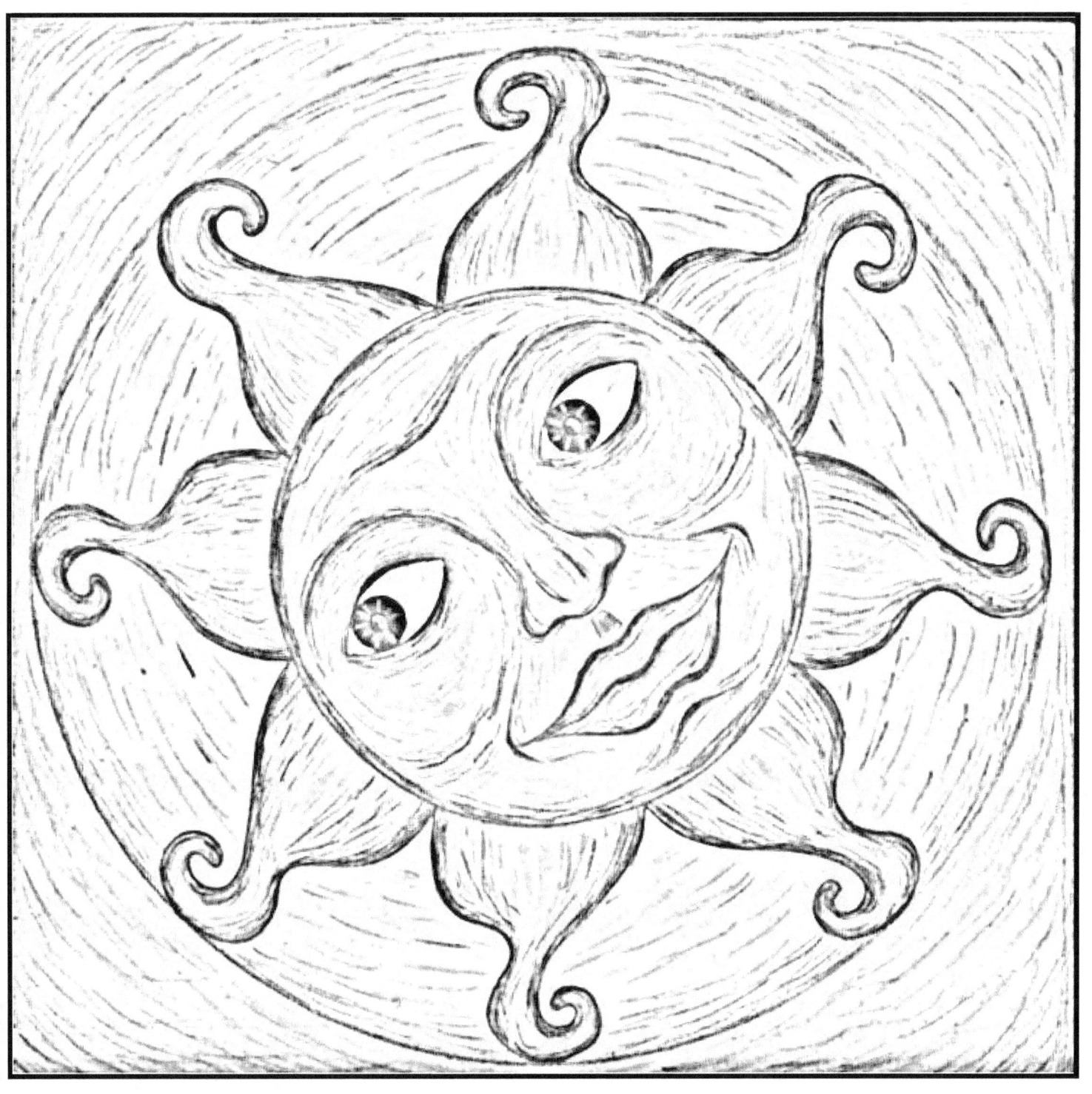

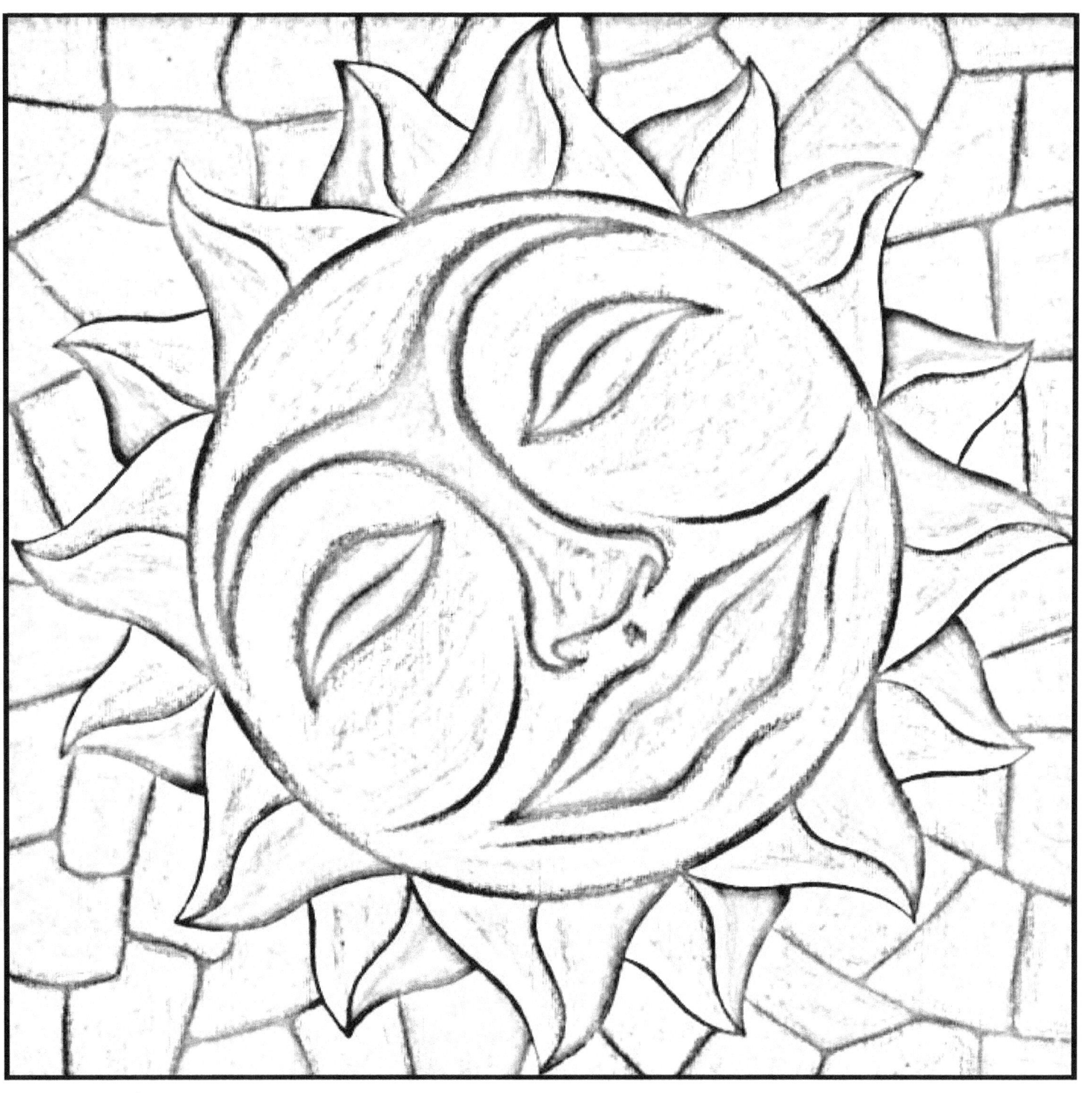

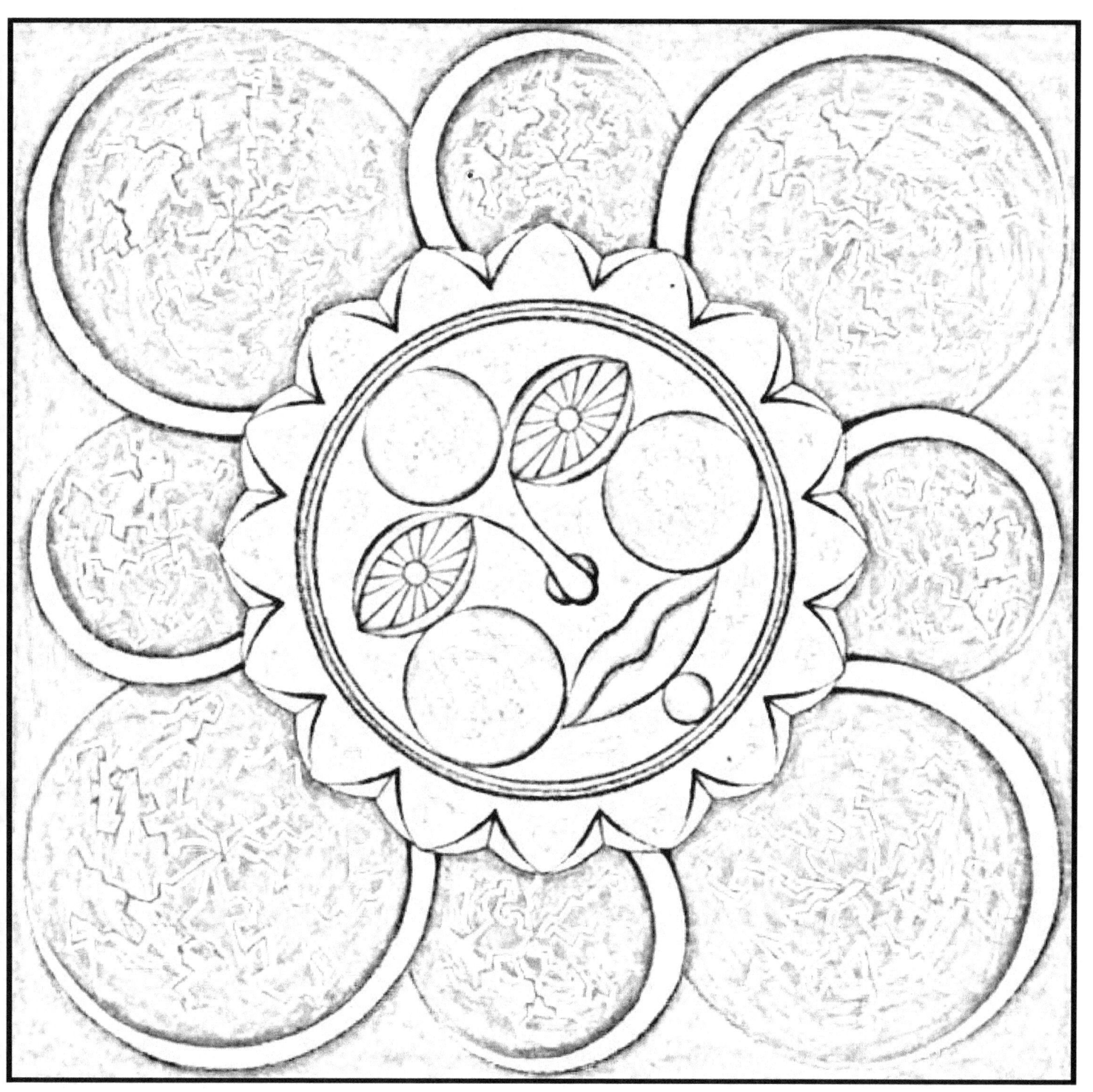

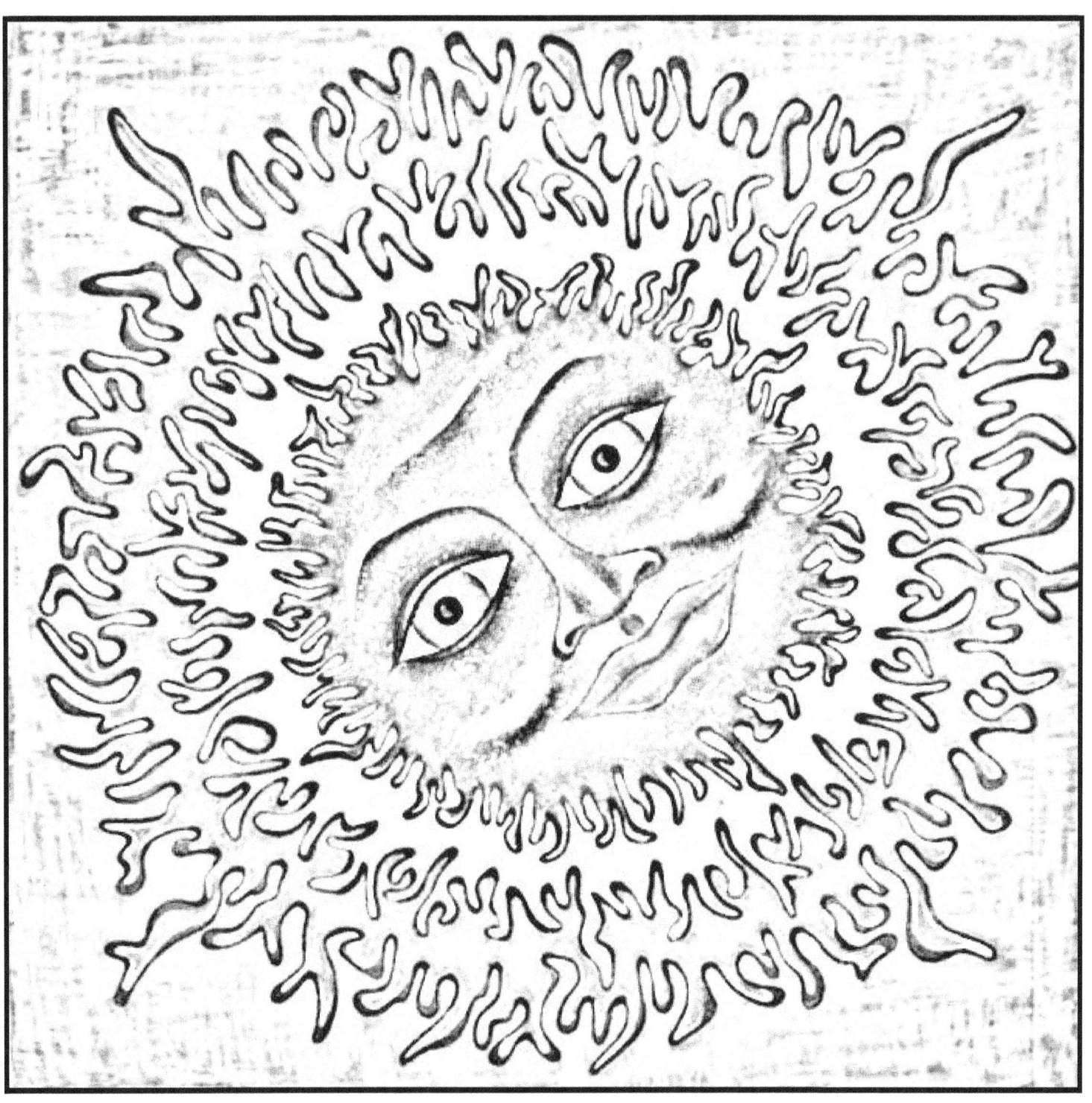

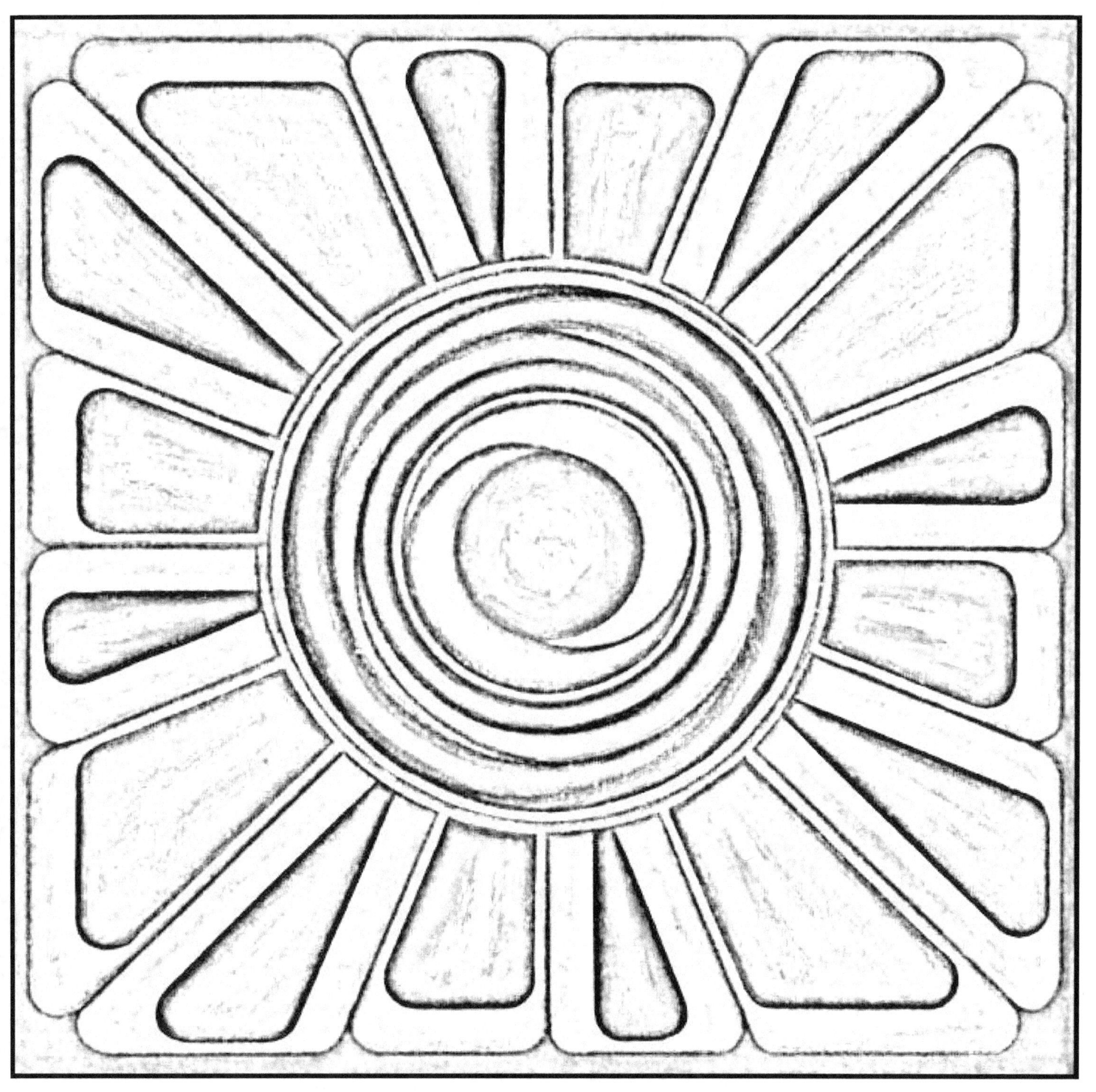

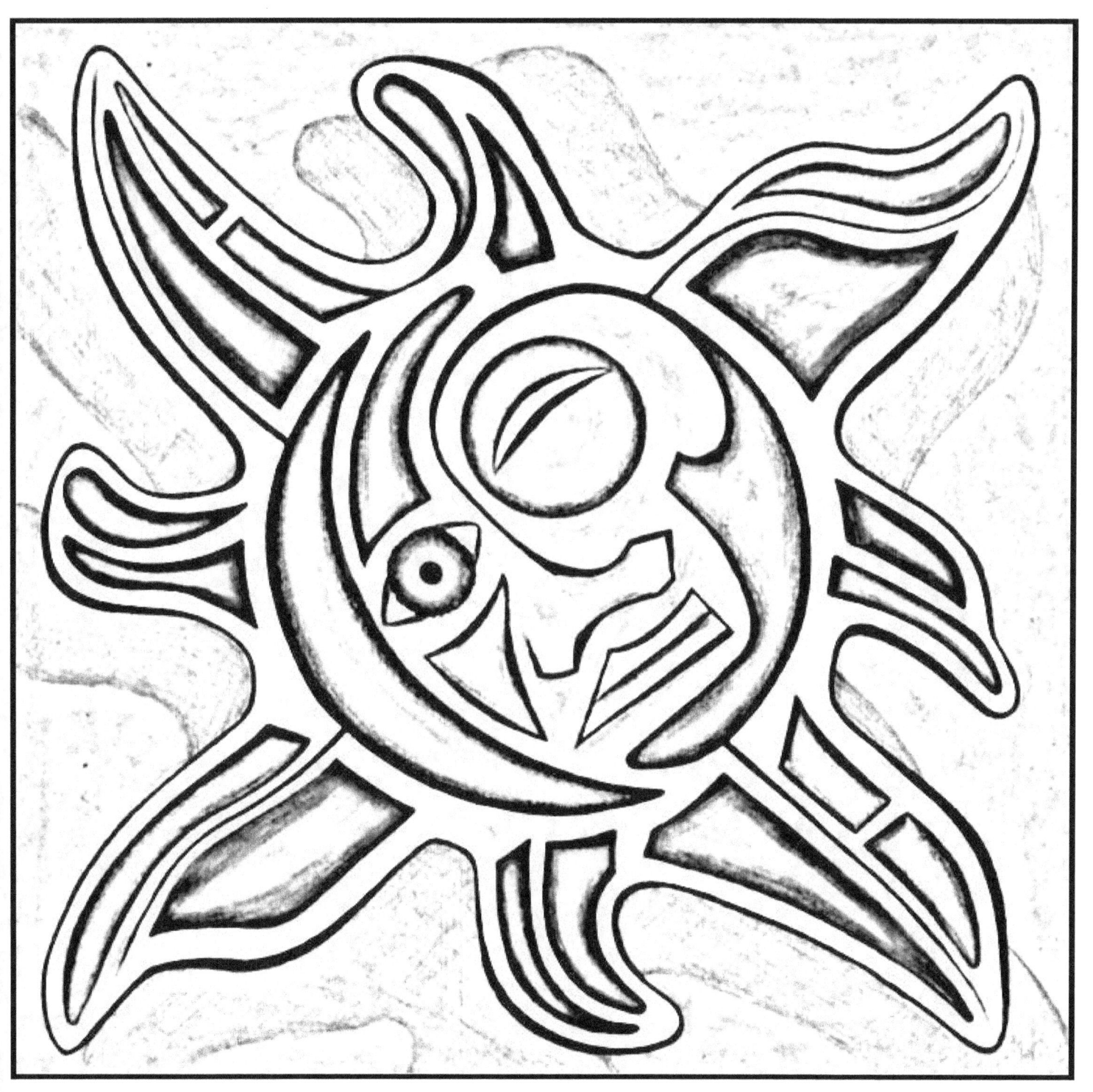

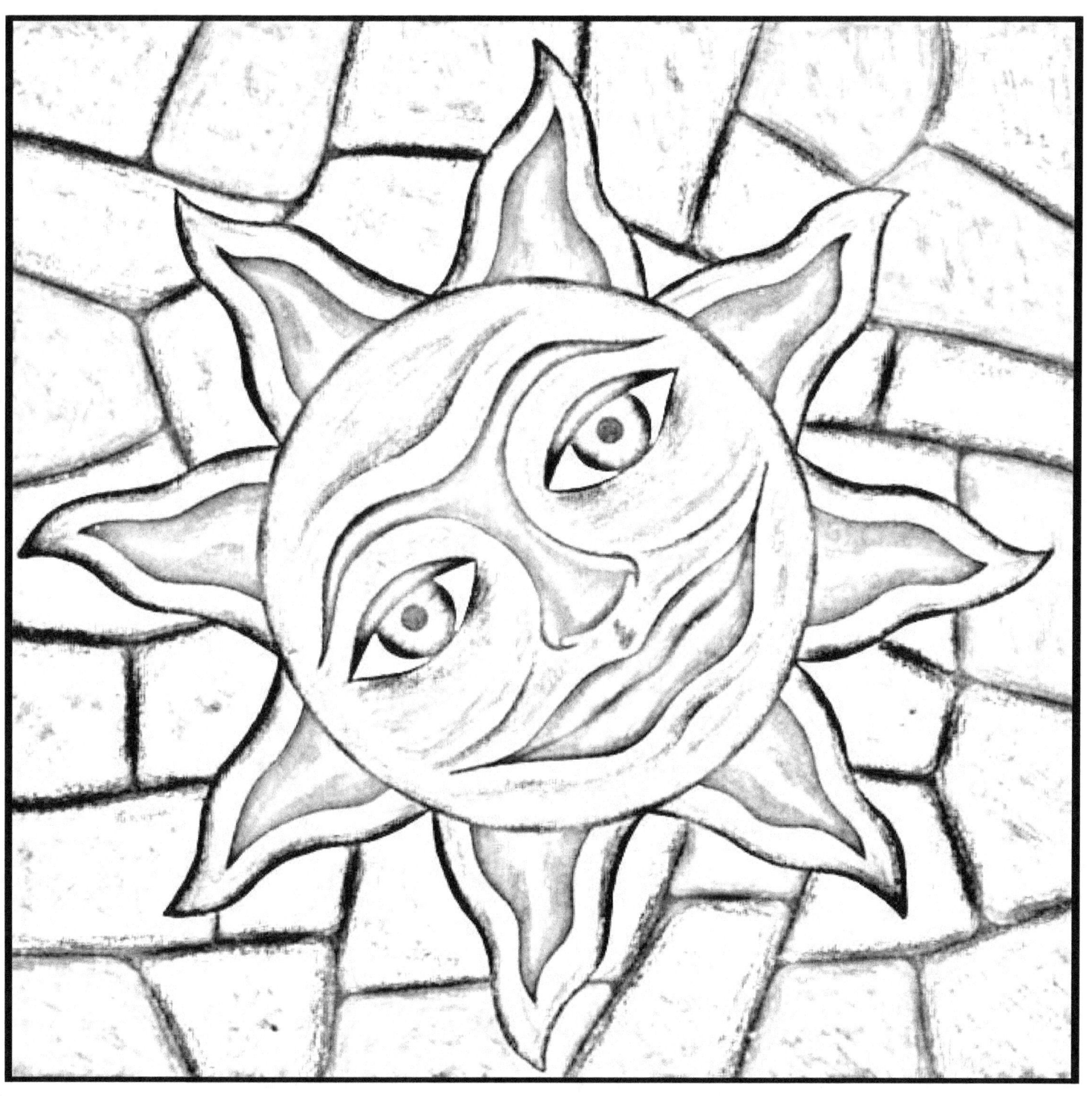